OPEN

FOR LEBANON

"A Lost Summer" is dedicated to the memory of our dearest friend and mentor Mai Ghoussoub, who loved life, Lebanon and literature. Her support was invaluable in the creation of this book, and she will be forever remembered through its pages and in our hearts.

ISBN 13: 978-0-86356-686-8

© Maureen Ali, 2008

Copyright of individual images and texts rests with the artists and authors

A full cip record for this book is available from the British Library.

A full cip record for this book is available from the Library of Congress.

Manufactured in Lebanon

SAQI

26 Westbourne Grove, London W2 5RH

825 Page Street, Suite 203, Berkeley, California 94710

Tabet Building, Mneimneh Street, Hamra, Beirut

www.saqibooks.com

Designed by Anna Ogden-Smith

BY AIR MAIL
PAR AVION

A LOST « SUMMER

Postcards from Lebanon

Edited by Maureen Ali

SAQI
London San Francisco Beirut

Since the signing of the Ta'if Accord in 1989, the Lebanese at home and abroad worked tirelessly to reclaim their country from the rubble of a merciless civil war. Immense resources were invested to rebuild industry, infrastructure and housing, while a fragmented society torn apart by 15 years of suffering began its healing process. The fruit of that labour was at its sweetest in the summer of 2006; the economy and tourism were booming, and increasing numbers of the Lebanese abroad returned to reinvest in their homeland. Lebanon was blooming again on memories of its golden past harnessed by the promise of a prosperous future.

Against this backdrop, it is no wonder that most inside and outside the country witnessed the events of the summer war of 2006 in utter disbelief. Before the seriousness of the situation had even sunk in, reports of blockades and air raids were emerging. Then, eerily familiar words from a bleak past came back to haunt us; cluster bombs, Katyushas, phosphorus. Lebanon was at war, again, face with a fierce enemy armed with a brutal arsenal.

For 33 days the war raged on. From abroad, many of us watched powerlessly as events unfolded on our TV screens. Although the images we saw angered and tested us, it was the messages of solidarity and steadfast defiance in the face of war that truly resonated within us. The stream of e-mails, blogs and text messages expressing the courage and emotions of those on the ground and those on the outside inspired us to organise ourselves and enter into a commitment to help Lebanon and our fellow Lebanese. From this commitment was born Lebanon United.

The horrors of war can never truly be reflected in the pages of a book. But what can be immortalised on paper

is the spirit that united a population emerging from a gruesome conflict with its head held high. In a less obvious way the summer war of 2006 was a test of that journey of national reconstruction that Lebanon embarked upon in 1989. The respect for each other as Lebanese during challenging times, the dignity with which we faced the outside world when many doubted our ability to stand united under attack, and the love we share for our country are all reflections of the unique spirit that we forged over the past 17 years. It is this spirit of solidarity that we have tried to capture in this book through the messages that came from the heart of those affected directly and indirectly by the war.

We hope that you enjoy this book, and we also hope that these pages can remind us, so we never forget, of the power of our unity when we call upon it and the strength of our determination when we stand together.

Lebanon United, January 2007

www.lebunited.org

I was with a friend at the Hammersmith Apollo in London at a Ben Harper concert... Towards the end he stopped singing and engaged the crowd.
He said: **"Who's from Australia here tonight?"**
The crowd roared.

{Kheiry Sammakieh}

Then he said:
"Who's from France?" *Again... the crowd roared...*
"England?" *Same reaction.* *He then went quiet for a whole minute and whispered:* **"Who's from Beirut?"** *My friend and I were the only people in the entire building screaming at the top of our lungs - heads up and proud. Ben Harper was shocked, pointed in our direction and re-asked the question to make sure and again we reacted in the same way.*
He then said: **"It's amazing to meet you guys, I love your country. Peace in the Middle East".**

July 12th, 2006

My friend calls me back a few hours later around 5am and says:

"THEY BOMBED THE AIRPORT"

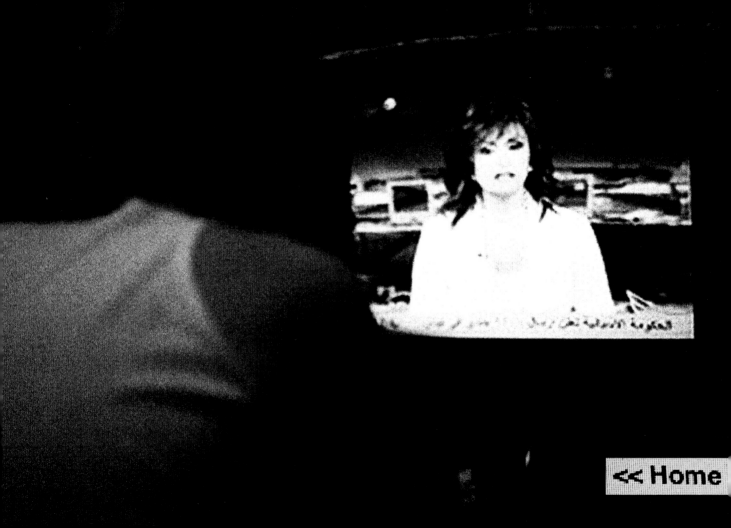

<< Home

[Enas Mtaweh]

Dial my mother.

She picks up.

"Allo?"

"Hi, Mom?"

HONE GOES DEAD.

It has been like this for the past

5 hours. Just imagine how it is

for those who can't even

complete the call.

posted by {Manar El-Chammas}

I remember the first Sunday of the war.

They **BOMBED** all Sunday night, so much that on Monday morning I could no longer see the sun.

Do you imagine, Beirut the city where the sun is always shining in summer; well on Monday July 17th Beirut was grey, dull, sad.

I could only see clouds, no sun. [Soraya Spahi]

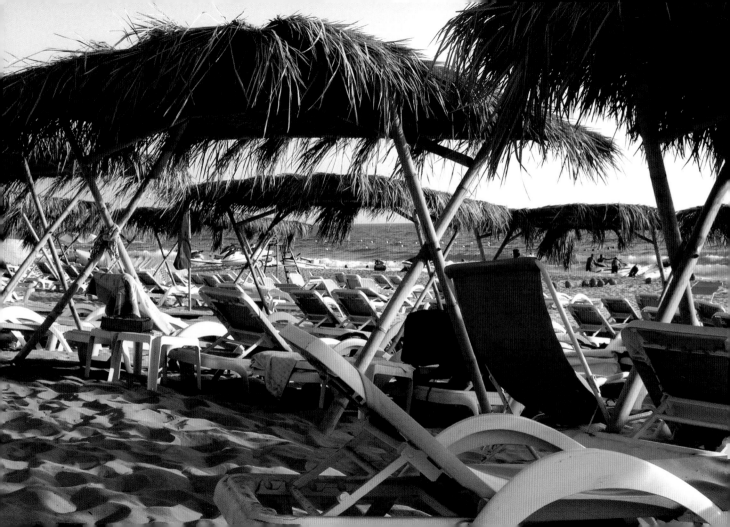

I have been living in a surreal vacuum.

All around the people of the First World are going about their daily business.

Joyful tourists are flocking around with cameras and shopping bags, people are discussing the World Cup final and Zidane's headbutt.

{Nadine Khouri}

All around me everything still looks the same; except that the surrounding sameness has taken on a silent eeriness, with the knowledge that my family

and friends are trapped in a blockade, increasingly scared and helpless, desperately seeking a ceasefire.

Perhaps the disaster is just another abstract newsflash for most, lost between Big Brother and some other inane TV series.

SOMEWHERE THERE, SOME SMALL IRRELEVANT COUNTRY.

Or maybe even a shrug, accompanied by the worn-out refrain:

"There is no hope for peace in the Middle East."

[Dyana Najdi]

{Muna Wehbe}

بتعرف؟ من ورا كلّ اللي صار. أوّل مرّة العالم

كلّه عم بيسمع بأسامينا .. أسامي حتّى نحنا ما

كنّا سامعين فيها . لازم تشوف كيف كانوا عم

يلفظوا "دير عامص" من شوى أو "دبعال"

أو "رشكناناي" . متل اللي ناطر حدا ينجّيه من

غول بيخوّف .

posted by [Nour El Assaad]

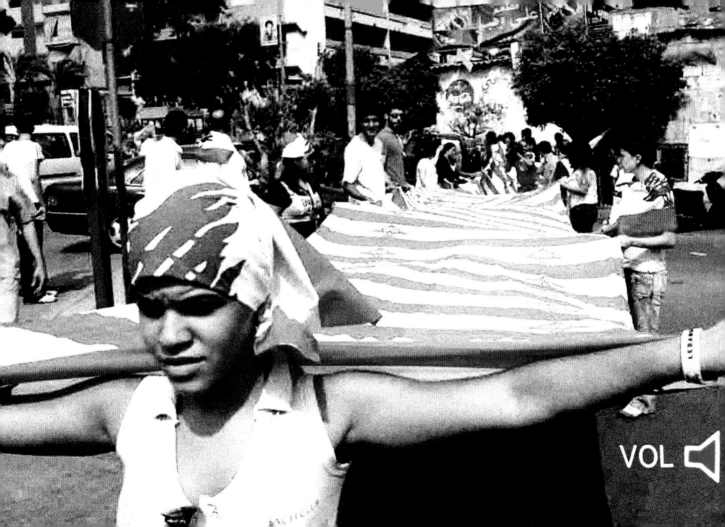

VOL 🔊

[Marwan Tahtah]

We are fuelled by our love of Lebanon, and anger and dismay at such an unjustified and unjustifiable war cutting like a knife through the beating heart of a country rejoicing in its recovery.

posted by {Souraya Ali}

The suffering is real, and getting worse. The wounds are deep. The deaths are mounting. Jose Narosky once said that in war, there are no unwounded soldiers. I think the same is true for civilians. Whether you are under bombardment, or in the relative calm of the mountains, you are scared and scarred. I get messages from friends huddled in nightclubs in Faraya, with a seemingly grotesque insouciance. But I don't judge them; I know it's a way of coping with tragic loss.

COLLECTIVE AMNESIA, *a willingness to erase what is happening.*

A wish, much like mine from the comfort and safety of London, to believe that this is a bad dream, and that we'll wake up to our shiny new Lebanon tomorrow.

 [Marwan Sahmarani]

VIA AIR MAIL {Nasri Atallah}

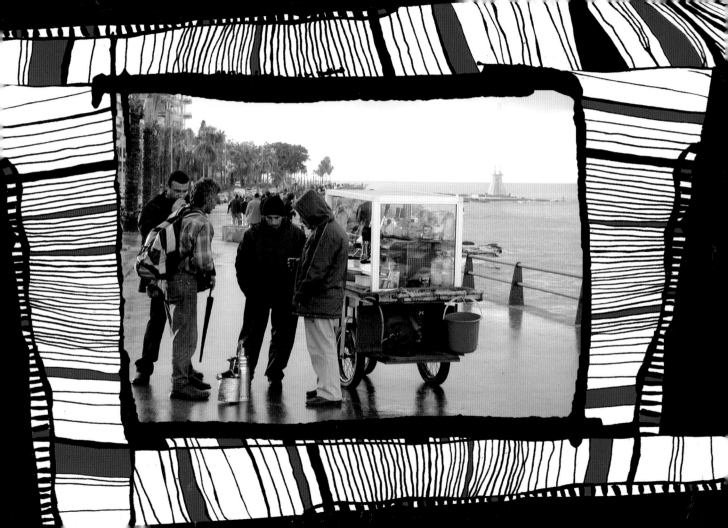

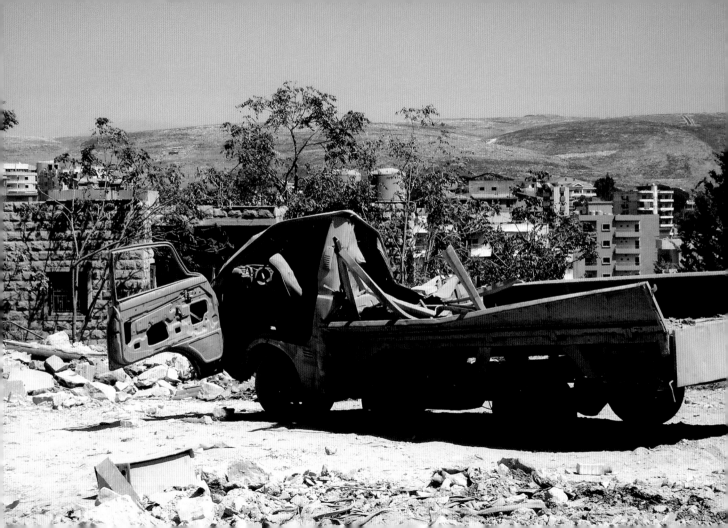

[Ramsay El-Asmar]

truckophobia

{Nadine Touma}

...THE SIGNS OF THE "TRUCKOPHOBIA" PSYCHOLOGICAL DISORDER APPEAR WHEN THE LEBANESE CITIZEN FINDS HIM OR HERSELF NEAR A TRUCK. The signs are:

>> **Screaming:** *"Ya mama camion"*

>> **Addressing the truck driver with a go go go go sign with the right hand**

>> **Fast heart palpitations**

>> **Sweat drops starting on the forehead spreading to the palms of the hands**

>> **Running in the opposite direction if walking in the streets**

>> **Driving very fast if in a car**

>> **Commenting on what the truck could be carrying:**

-*Chou what do you think?*

-*No it seems like cloth rolls to me!*

-*Yiy! Maybe the Israelis from their airplanes will think that the rolls are rockets and they will bomb us! Come on let's go, yallah!*

-*No walaw they are not that stupid!*

-*Ya haram not that stupid!!!!! They mistook watermelons for bombs and they won't mistake cloth rolls for rockets?????*

>> **Once the truck is far enough and the Lebanese citizen is safe from danger, they say:** *"El hamdellah, Zamatna, we made it"*

>> **Then if on any anti-stress or anti-depressant or any kind of relaxing medication, they pop a pill in their mouth and swallow it dry.**

Psychiatrists and psychotherapists in Lebanon are looking for a cure for the **truckophobia** disorder and welcome any suggestions from the esteemed international psychiatric boards unless the latter are as quiet and as numb as their political leaders

STERILE | EO

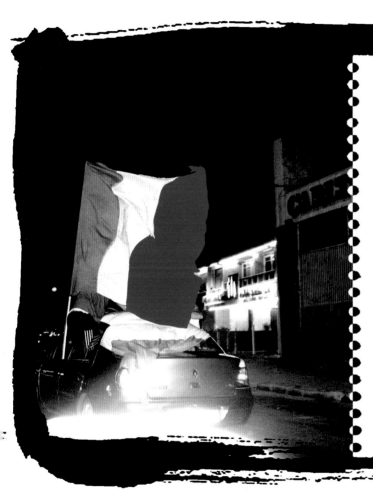

 [Muna Wehbe]

VIA AIR MAIL

'I've realised why Israel is attacking us again', he said with a big smile on his face, 'It's because Italy won the World Cup. It's just like in 1982.'

{Alfred Tarazi}

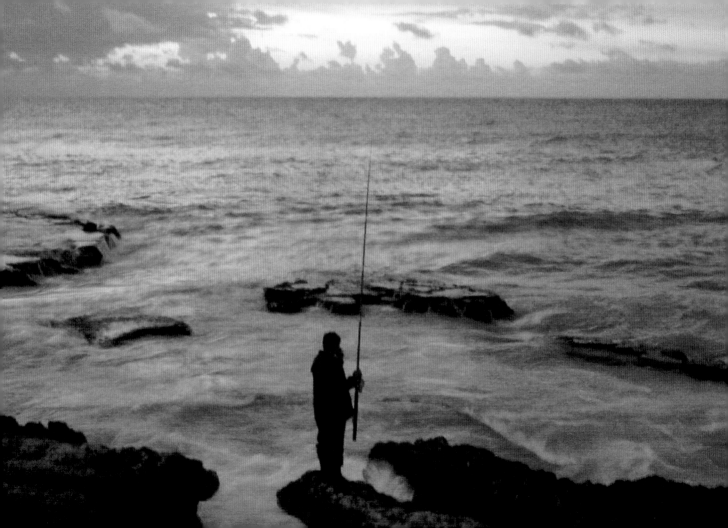

[Said Durra]

I look for the familiar faces of the fishermen with whom I spent tender moments

I look for the faces of the children who guided me through their streets

Invited me to their homes, fed me at their tables

Told me tales of love stories between fishermen and waiting mermaids.

I call them and can't get through.

I can't stop the tears rolling rolling rolling.

I THINK I HAVE RECOGNISED THE DEAD FACE OF A LITTLE GIRL I KNOW

That we have filmed.

I am weeping

{Nadine Touma}
post

{ Joumana Seikaly }

 [Souraya Ali]

IT'S FUNNY HOW OLD HABITS DIE HARD.

I got home yesterday, and calmly prepared **3** bags:

one has all my papers, my credit cards, my insurance, my passport, my keys, my glasses...

another has a change of clothes, enough for three days and two small airplane blankets, deodorant, toothbrush.

the third has all my valuable gear, 2 cameras, my iPod, my video cam, and all the chargers thereof.

a fourth (unpacked but neatly arranged on my bed) will contain all my diaries and pictures. **THIS IS THE EMERGENCY LAST BAG.**

I will go nowhere without my **memories.**

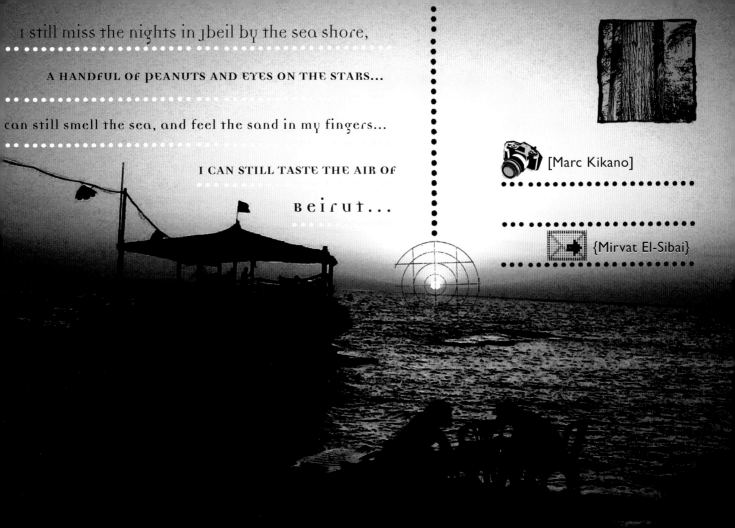

I still miss the nights in Jbeil by the sea shore,

A HANDFUL OF PEANUTS AND EYES ON THE STARS...

can still smell the sea, and feel the sand in my fingers...

I CAN STILL TASTE THE AIR OF

Beirut...

[Marc Kikano]

{Mirvat El-Sibai}

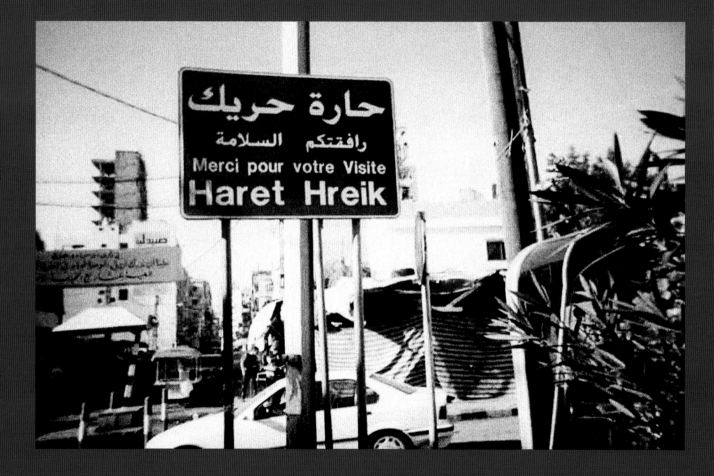

An Israeli arrives at London's Heathrow airport. As he fills out a form, the customs officer asks him:

"Occupation?"

The Israeli promptly replies: "No, just visiting!"

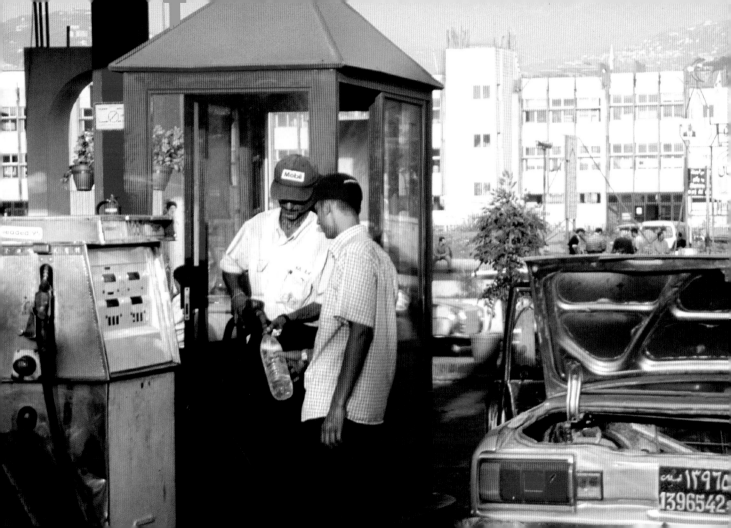

This is a place where you greet everyone with three kisses, where you thank a taxi driver by saying 'God bless your hands' once you have negotiated your fare, where power cuts and water shortages are the norm, toilet paper goes in the bin because the sewage system can't cope, men walk down the road arm in arm, 'one way' signs and 'no entry' signs are merely suggestions, soldiers with machine guns lounge on broken plastic chairs at the side of the street, children sell packets of tissues and chewing gum in the middle of the motorway, skinny cats pick their way gingerly through rubbish dumps, and Hummers screech along the sea front beside rust buckets which rattle with every shift of the gear stick.

[Eric Trometer]

BEIRUT IS A CITY OF CONTRASTS

posted by {Souraya Ali}

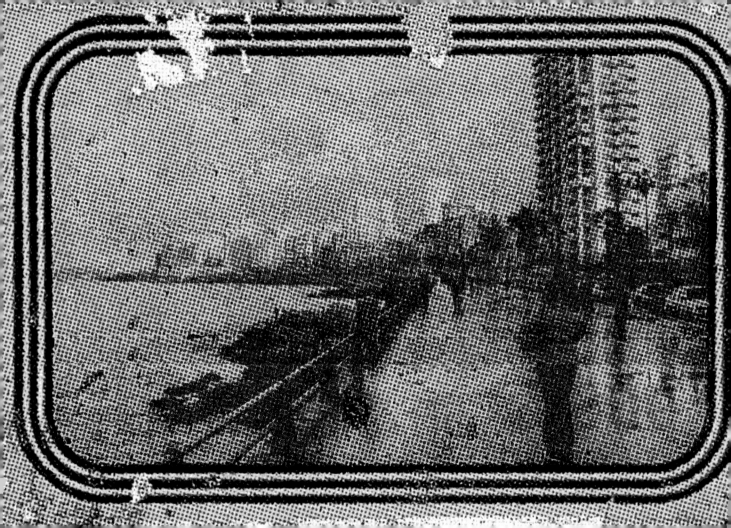

 [Marwan Sahmarani]

Beirut

 – *peace to Beirut with all my heart*

 And kisses – *to the sea and clouds,*
To the rock of a city that
looks like an old sailor's face.
 From the soul of her people she makes wine,
From their sweat, she makes
bread and jasmine.

So how did it come to taste of smoke and fire?

{Translation from Fairuz song "Beirut",
 Lyrics by Joseph Harb}

SOTTO BEIRUT, SOTTO IL SUOLO DELLA DISCORDIA
C'È CHI HA SOTTERRATO ATTENZIONI,
C'È CHI HA SOTTERRATO AMICI,
C'È CHI HA SOTTERRATO FRATELLI.
SOPRA BEIRUT C'È CHI FUGGE LE PREGHIERE,
C'È CHI AMA IL PROSSIMO COME SE DOVESSE AMARLO.
FUORI BEIRUT C'È IL CUORE CORROTTO DELL'UNICO
UOMO CAPACE DI PAURA VERA.
DENTRO BEIRUT C'È L'UNICA DONNA CON DUE CUORI.
I CUORI SONO MEDAGLIE AL VALORE.
DA UN LATO NASCE IL SOLE, DALL'ALTRO MUORE.

{Luca Corbini}

[Mazen Kerbaj]

Beneath Beirut, beneath the soil of discord
 There are those who have buried kindness,
There are those who have buried friends,
 There are those who have buried brothers.
Above Beirut there are those who flee from prayers,
 There are those who love their fellowmen as they should.
Outside Beirut is the damaged heart of one man
capable of real fear.
 Inside Beirut is the only woman with two hearts.
 Hearts are our medals of valour.
On one side the sun rises, on the other it dies.

[Eric Trometer]

What can I tell my almost 5 year old nephew when he comes up to me and asks me:

"Why do the Israelis hate us?
Why are they killing us?
Who is Hezbollah?
Who are the bad guys?
Are these real bombs or are they like in the movies?
Why are people crying all the time?
Are too many people dying?
Can't Superman help the good guys from the naughty ones?"

VIA AIR MAIL
{Souraya El Far}

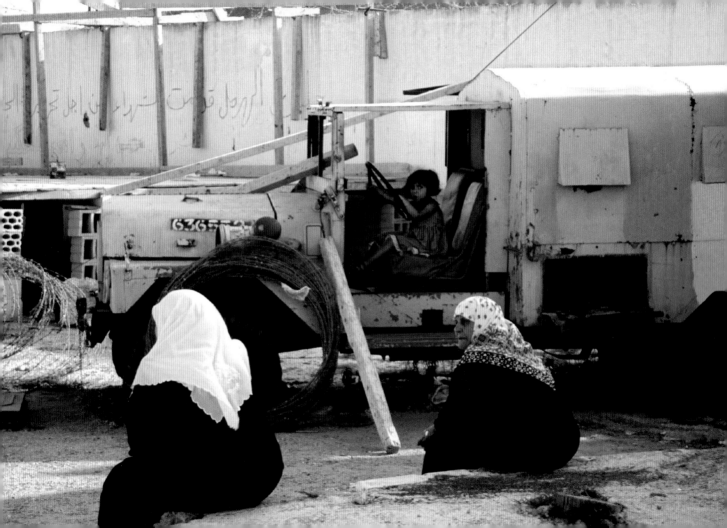

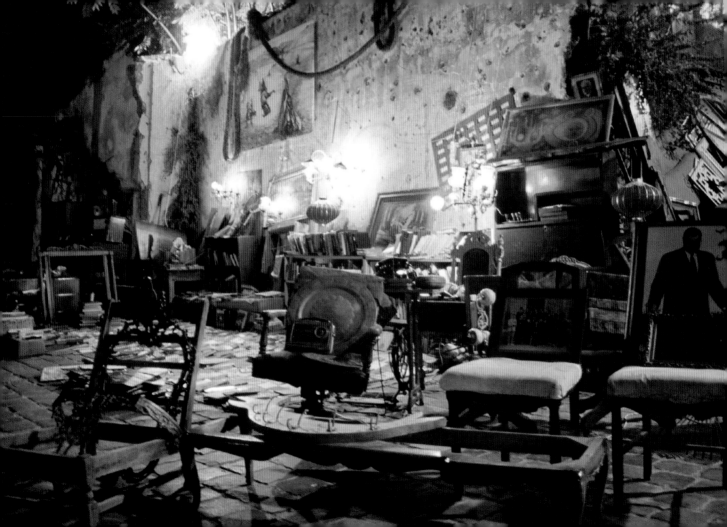

 [Eric Trometer]

I'VE WATCHED HUNDREDS OF BUILDINGS FALL SINCE THE WAR STARTED, AND NOT ONE, NOT ONE, HAD A PRESERVED ROOM. THEY CRUMBLE LIKE SANDCASTLES, AND THE WAVES MAKE NO DIFFERENCE BETWEEN A LIVING ROOM AND A BEDROOM, OR BETWEEN A MATTRESS AND A BED.

post {Maya Osman}

Last night my husband broke my heart. He wasn't worried about the childhood playground he had lost a few days ago anymore or about our house being occupied by the displaced. Nor was he anxious about finding a new house for his parents when the aggression is over (I hope before I give birth!) For the first time, I saw anguish on his face. "If the house (his parents') is totally on the ground as I have been told today, then there won't be any pictures of Nazem left." You see, Nazem is Moussa's eldest brother. He died last December. He was only 47.

post {Mira Bachir}

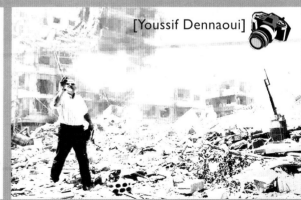

[Youssif Dennaoui]

That street is

<< Home

I wonder where did the old man that pushes a grocery cart, and sells the best fruit in the neighbourhood go?

Did he take 3arabeyto [his cart] with him?

posted by {Maya Osman} [Marwan Tahtah]

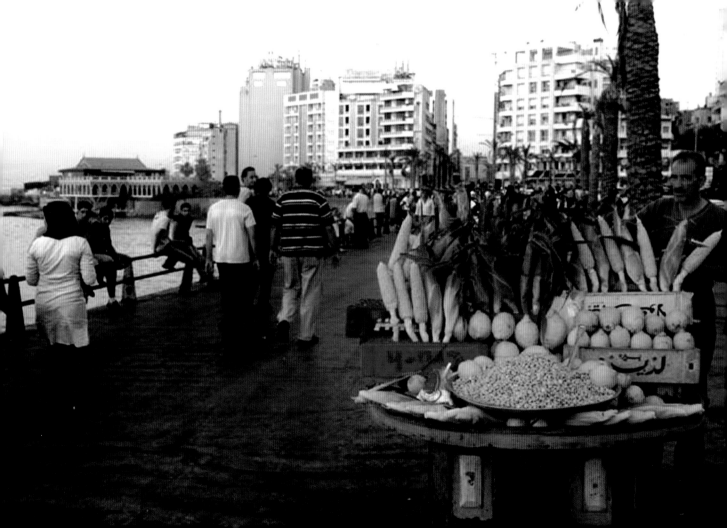

I just wanted to thank u for the ipod.

I listen to it every morning when I wake up & at night (so that I don't hear the planes & explosions).
I love it & I LOVE U!

[Said Durra]

August 08 @ 12.51 am
{sms from Maya Osman}

~.~ Glue your image here ~.~

~ . ~ Write your quote here ~ . ~

POST

[]

{ }

[Karen Klink]

{Maureen Ali}

I guess the menacing whine of an approaching fighter jet is at its most potent at four in the morning. **As the fitful city holds its breath, the planes pass overhead circling slowly time and again preparing to drop their payload. The sickening thump of the bomb hitting the ground passes right through the body, jarring the nerves and pummelling the stomach. *We left with heavy hearts, impotent to do anything if we stayed, but filled with guilt to be getting out.***

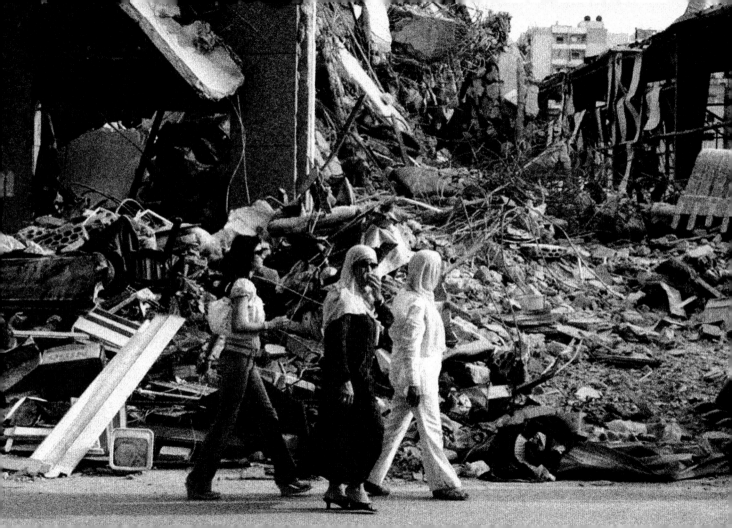

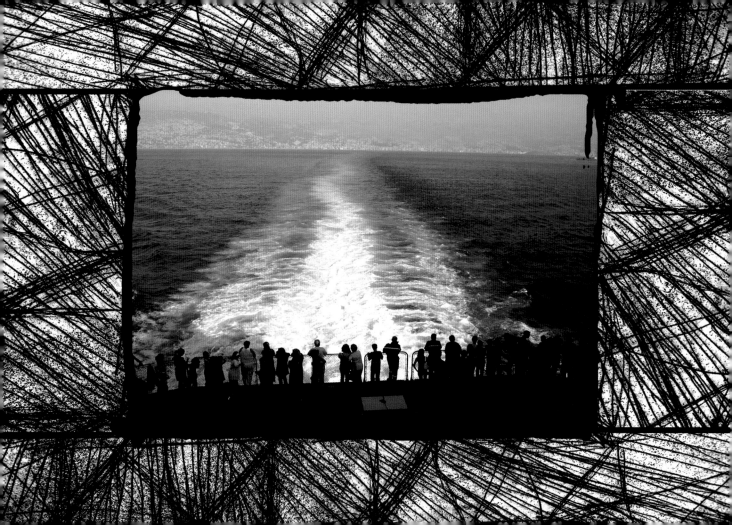

I don't remember packing my luggage; it was done in a hurry, in great panic but I remember leaving Beirut's port with the French evacuation ship. As the ship left the port, I stood on the deck of the ship and I saw Beirut. It was polluted, it was grey, it seemed empty, miserable. There had been so much bombing that the city was sub-merged in smoke, I could no longer distinguish the buildings. The only thing I could see was the dome of the turquoise mosque where Hariri is buried. The turquoise seems like a sign telling us not to let go, but to still believe in Lebanon.

posted by {Shaden Itani}

MEDITERRÁNIA

24.0

[Jihane Tohme]

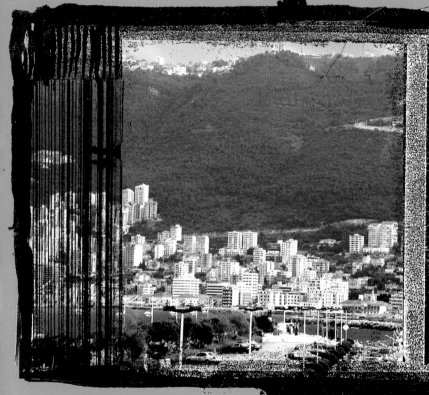

We are safe and sound in Kuwait. We arrived here a few days ago, after a horrible journey to say the least. It took us four (four, can you believe it?!) long days of stress and fear and at times humiliation to make it out of Beirut and into Turkey. We made it safely to Kuwait a few days later, but we are heartbroken to have left behind our families and friends. I am still in shock over what happened in Lebanon. I had arrived to Beirut just a few days before this horrible episode started. Lebanon was packed full with tourists and was glowing with the promise of a beautiful summer. I still find it hard to believe it is now at war.

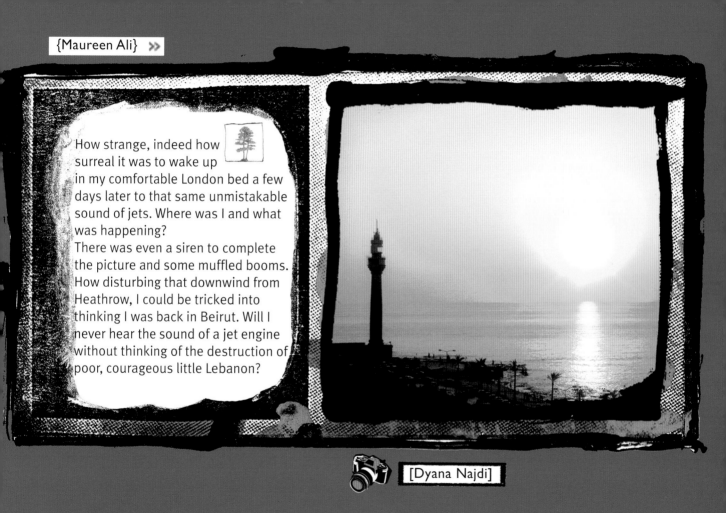

{Maureen Ali} »

How strange, indeed how surreal it was to wake up in my comfortable London bed a few days later to that same unmistakable sound of jets. Where was I and what was happening?
There was even a siren to complete the picture and some muffled booms. How disturbing that downwind from Heathrow, I could be tricked into thinking I was back in Beirut. Will I never hear the sound of a jet engine without thinking of the destruction of poor, courageous little Lebanon?

[Dyana Najdi]

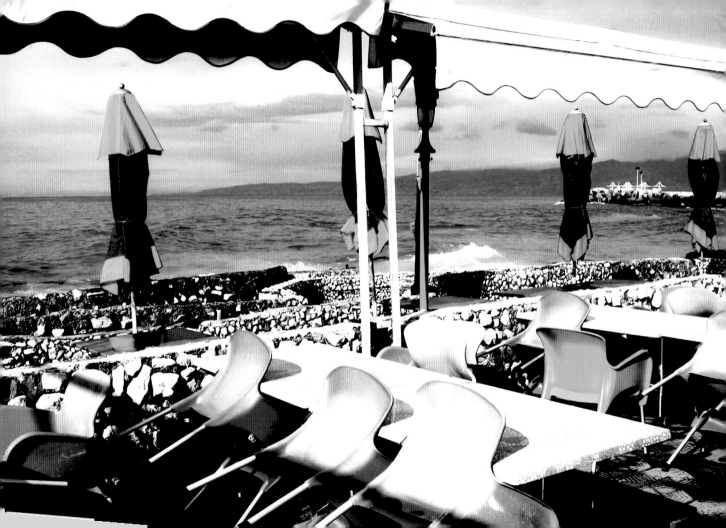

From the shores of the

Mediterranean, I prefer to remember

the warmth and the dance.

From Beirut,

I do not want to reproduce the sadness,

but the once noisy, dancing

and cosmopolitan city.

 [Anna Ogden-Smith]

{Mai Ghoussoub}

 [Unknown]

It took me 23 years to memorise the streets and alleys of dahyeh, and it took them less than a week to cease its existence. There's nothing left of it. I saw a man on TV standing in the middle of the ruins in Haret Hreik looking around in astonishment. A reporter came to ask him what's wrong with him. He replied that he can't seem to find his house. He didn't even know if he's in the right street, or the right neighbourhood. They all look the same now. Sfeir's bridge was also totally destroyed. It is the bridge that links Tareek El-Matar to Hazmieh, and it was almost completed by the time we had to leave Borj.

》

{Maya Osman}

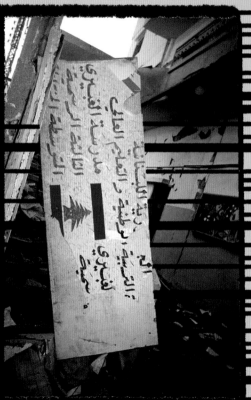

I HAD SEEN THE PICTURES ON TV, BUT NONE OF THEM HAD SHOWN THE DRESSES OR THE BLOUSES OR THE TOYS STILL CAUGHT IN THE PILES OF CONCRETE THAT WERE PEOPLE'S HOMES. HASSAN HAD HIS HOME BOMBED AND IS LIVING IN IT NOW, AVOIDING THE HOLE IN THE MIDDLE OF HIS SON'S BEDROOM. "WHY ARE YOU LIVING IN YOU HOME NOW? YOU CAN RENT A FLAT AWAY FROM THE DAHYEH UNTIL YOU RENOVATE YOUR FLAT", ASK HIM.

"I WANT TO BE HOME, I'M USED TO IT HERE, THIS IS MY NEIGHBOURHOOD." 《

{Mai Ghoussoub}

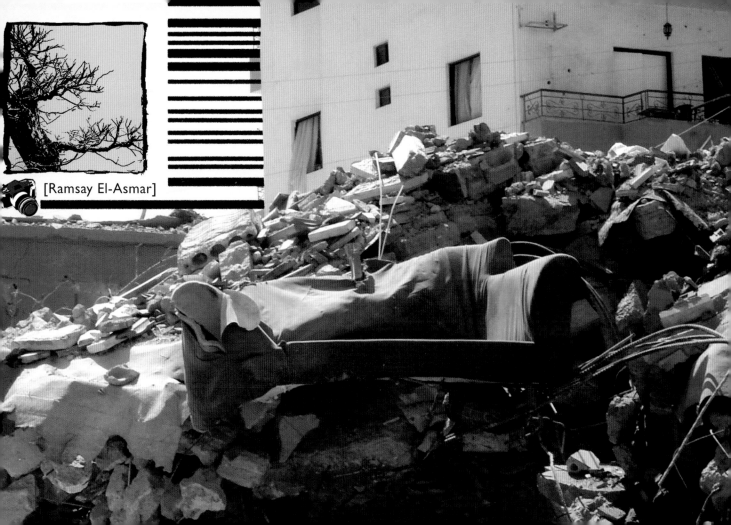

[Ramsay El-Asmar]

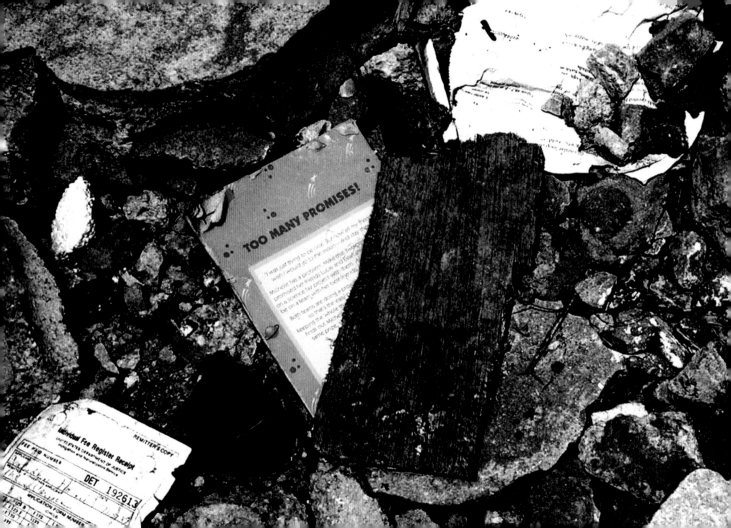

TOO MANY PROMISES!

"I was just trying to be nice. But now all my friends wish I would go to the moon... And stay there! Michelle has a problem. Making things worse, I promised her friends Lucas and Sarah she'd be on a team for their project with them.

Both teams are doing a project, so that's the issue keeping the whole team together. And I have to figure out... We're all doing the same project..."

I turned to the CNN website and watched one of the videos highlighting events in the aftermath of the Qana massacre. This is what I saw. I saw a man of maybe fifty years, standing next to a line of bagged children who, just yesterday, could not hide far enough underground to shelter themselves, and who today finally could. I saw him walk towards one of those long stemmed flowering plants, rip a branch with two blooming dark pink flowers, and throw it on the bagged lifeless little bodies lying peacefully on the ground. And then he spoke. And I felt ashamed, ashamed and soiled by all the hatred and anger that took me over, and made me into someone I could not recognise. This is what he said.

HE said: "OUR CHILDREN ARE DEAD. BUT THIS FLOWER IS MY ANSWER. THEY WILL NOT TURN US INTO MONSTERS".

No. They won't.
Those children never died, and never will. But I did, and today, I.. I thank you, for bringing me back to life.

[Rola Khayyat]

{Fouad Boulos}

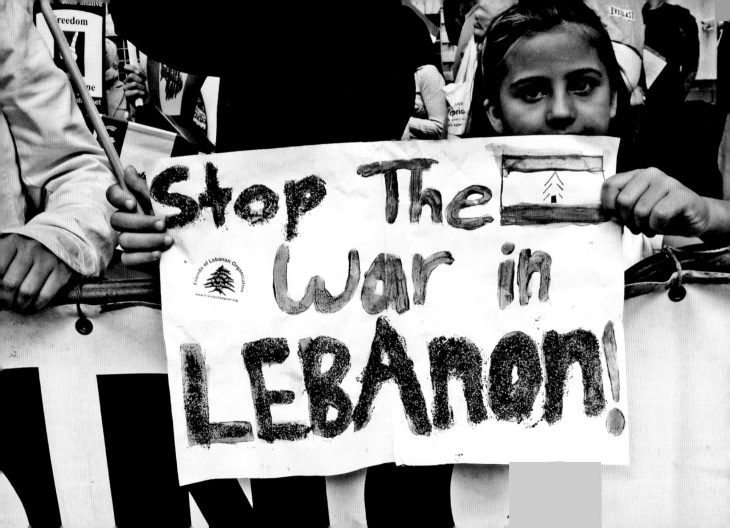

When I was 2 years old, until I was 5, the worst bombing and crimes took place.

When my siblings were about the same age, the same acts took place.

For a while, I thought that war is like chickenpox: it happens to everyone at a certain early age.

[Natalie Naccache]

posted by {Wadiaa Khoury}

WHAT FRIGHTENS ME THE MOST IS THAT

THIS IS WHAT PEOPLE MUST'VE THOUGHT

BACK IN 1975.

 It'll be over this week, let's just wait and see. [Manar El-Chammas]

And before they knew it, fifteen years had passed...

What I fear more than coming back to a disfigured home is coming back fifteen years later,

LIKE MY PARENTS

DID ONCE BEFORE.

{Rasha Kahil} post

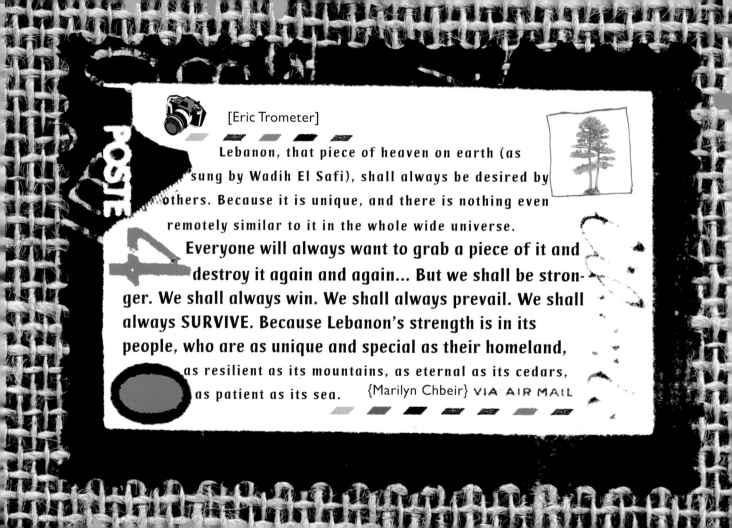

[Eric Trometer]

Lebanon, that piece of heaven on earth (as sung by Wadih El Safi), shall always be desired by others. Because it is unique, and there is nothing even remotely similar to it in the whole wide universe. Everyone will always want to grab a piece of it and destroy it again and again... But we shall be stronger. We shall always win. We shall always prevail. We shall always SURVIVE. Because Lebanon's strength is in its people, who are as unique and special as their homeland, as resilient as its mountains, as eternal as its cedars, as patient as its sea. {Marilyn Chbeir} VIA AIR MAIL

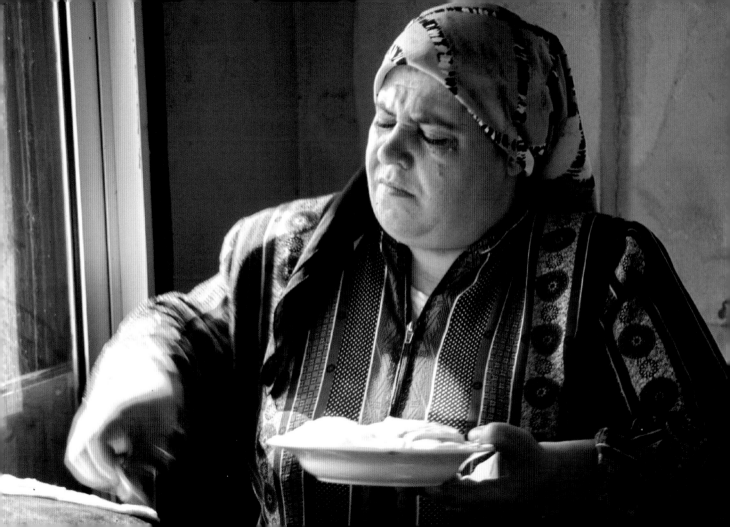

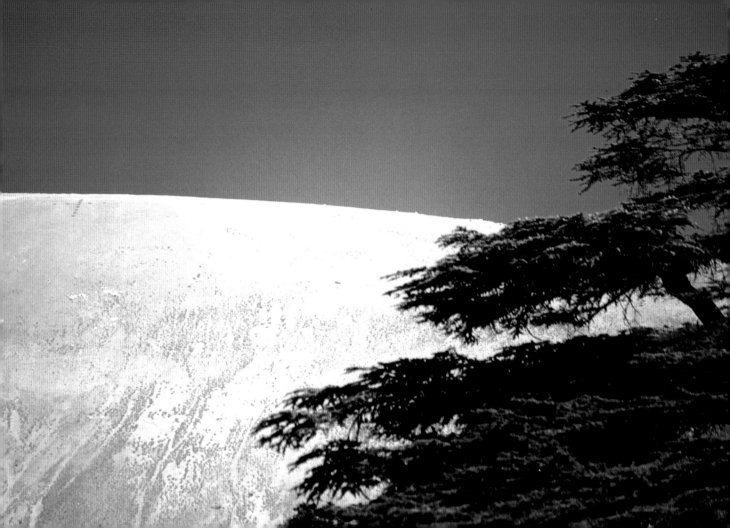

A bout de souffle,
je vois à l'horizon un pic vert.
Un point d'interrogation.
Une chaîne montagneuse qui s'annonce.
Un sourire.
Au dessus des nuages,
un sommet se révèle brusquement.
Un mont. Le Liban. Mon Liban.

 [Gonzalo Olmos]

EXPEDITEUR: {Serge Najjar}

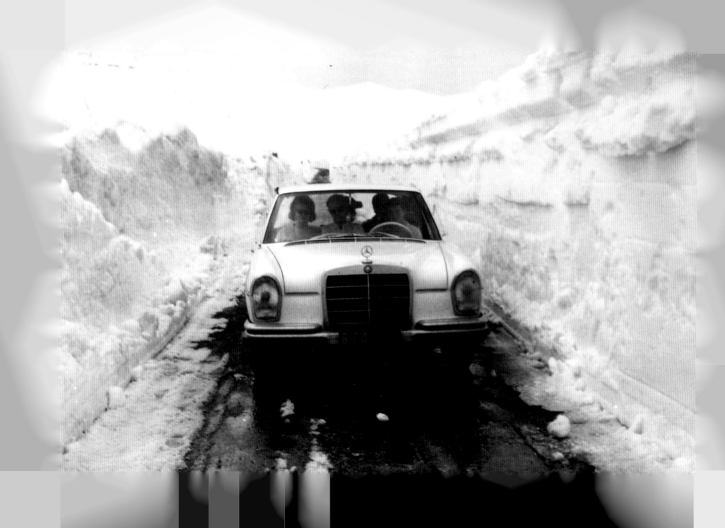

A Lebanese guy rushes
to the dentist in a panic:

"Please take out my bridge before
the Israelis bomb it!"

 [Souraya Ali]

We love music, women, men, fashion, food... we love to entertain and we love to be entertained... we love the sun and the snow.. the heat and the cold... we love football hehe... never seen so many Lebanese turn Italian so quickly!

{Christian Ghammachi}

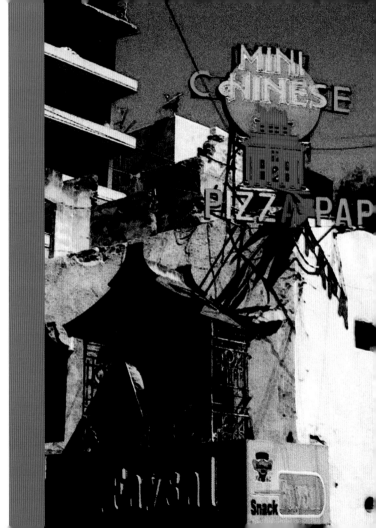

is year there was an incredible atmosphere thanks, rather bizarrely, to [Souraya Ali]
e World Cup. I never would have thought it, but Lebanon is football mad, and apparently
ways has been. A family friend told me that throughout the 17 year civil war, whenever the World
up came around, the fighting would stop as everybody stayed home to watch the matches. This
ear Beirut was covered with flags from all over the world... Having no team of their own to support
or indeed one of any of their neighbours — the Lebanese support everyone.
ter every match, no matter who won, fireworks went off around the city and people streamed
{Souraya Ali} into the streets blowing whistles and singing with their arms outstretched.

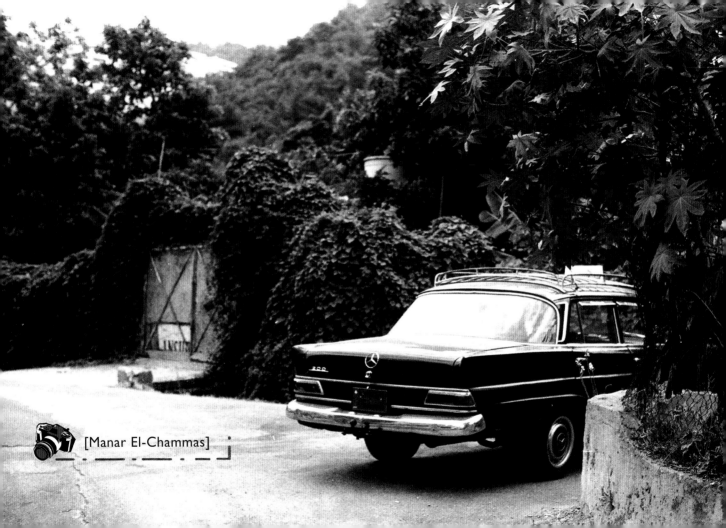

I love Beirut because it will never die,
I love Beirut because it has seen empires rise and fall and it remains, I love
Beirut because even as we suffer, we are steadfast,
and people go about their business. I love Beirut for
the old lady who can hardly walk, yet everyday opposite my house comes out and feeds the stray cats.
I love the sounds of Beirut : the service beeping,
the sound of the Sukleen trucks, the shout of the darake:

"Yella ya marcedes, imche".

posted by {Ibrahim Debbas}

 [Souraya Ali]

*I love Beirut because the Beirutis will not
accept anyone to occupy them and rule over them.
I love Beirut because we feel that it is better to die on our
feet than to live on our knees. I love Beirut because to
paraphrase what Gibran said about Lebanon: "Had Beirut not
my city I would have chosen it to be."
I love Beirut because there is no city like it.*

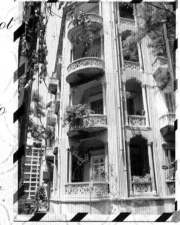

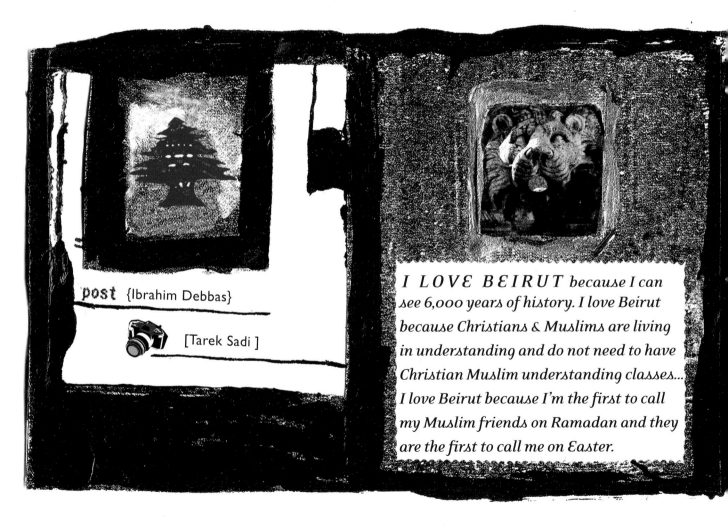

post {Ibrahim Debbas}

[Tarek Sadi]

I LOVE BEIRUT because I can see 6,000 years of history. I love Beirut because Christians & Muslims are living in understanding and do not need to have Christian Muslim understanding classes... I love Beirut because I'm the first to call my Muslim friends on Ramadan and they are the first to call me on Easter.

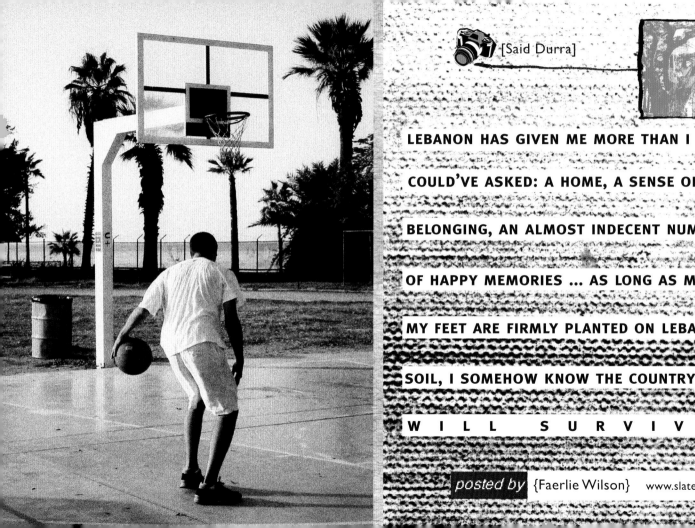

 [Said Durra]

LEBANON HAS GIVEN ME MORE THAN I EVE

COULD'VE ASKED: A HOME, A SENSE OF

BELONGING, AN ALMOST INDECENT NUMBER

OF HAPPY MEMORIES ... AS LONG AS MY

MY FEET ARE FIRMLY PLANTED ON LEBANES

SOIL, I SOMEHOW KNOW THE COUNTRY

W I L L S U R V I V E

posted by {Faerlie Wilson} www.slate.com

{David Shearer}

VIA AIR MAIL

What other country could experience such a mass movement of its citizens in the heat of war and have virtually no incidence of hunger, malnutrition or deadly disease? In my experience, it's simply unprecedented. Lebanese people proved in their compassion to be a model for the world. On a personal note, it has been an honour and a privilege for me to work with the people of Lebanon in their time of crisis. They've taught me a lesson about compassion and solidarity in the face of turmoil. I have no doubt that their wonderful energy and sense of optimism will be the mortar for building a better country than the one that has been so painfully damaged.

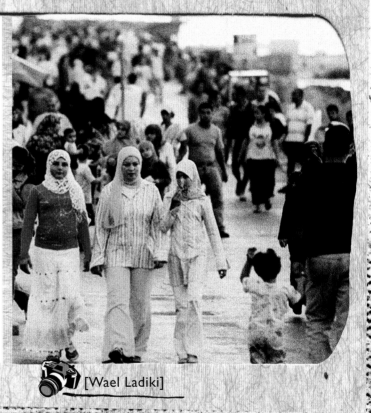

[Wael Ladiki]

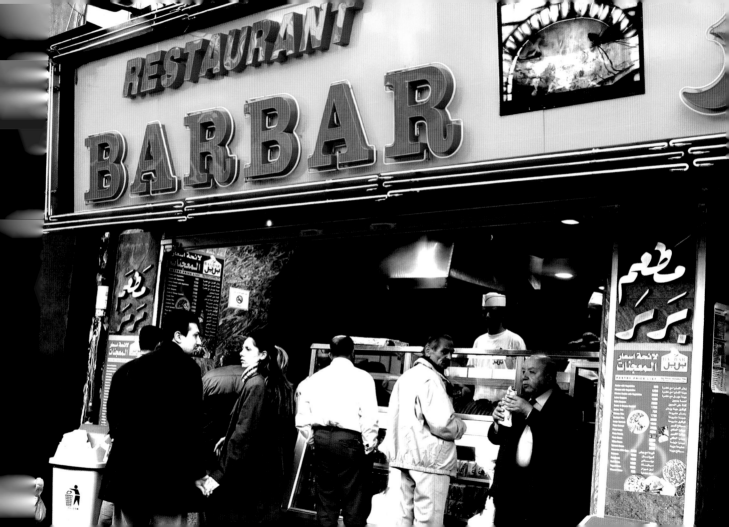

[Muna Wehbe]

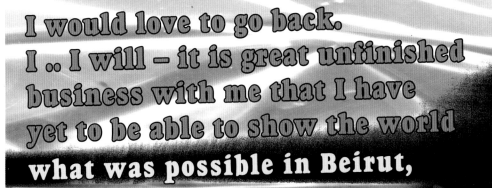

I would love to go back.
I .. I will – it is great unfinished
business with me that I have
yet to be able to show the world
what was possible in Beirut,

how good the food, how nice
the people I met, how hopeful
a situation I saw for only two
brief days.

{Tony Bourdain}

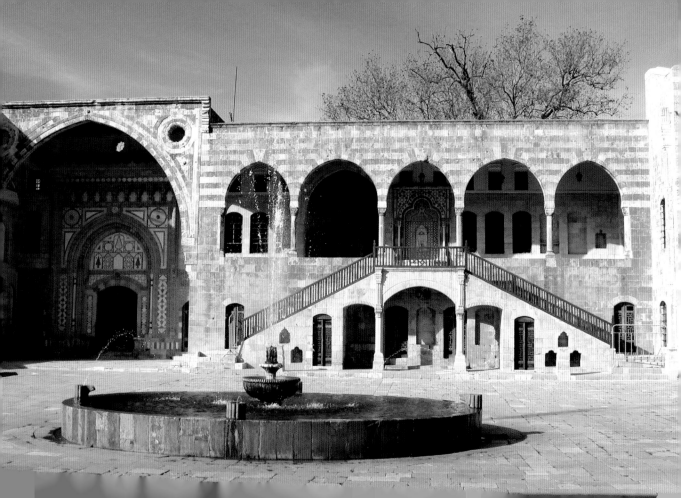

Don't be defeated... work... embrace life... succeed... and LIVE. Our accomplishments are Lebanon's accomplishments... we are the future and the ambassadors of Lebanon. If we fail... Lebanon fails... go out... embrace life... and always have Lebanon in your heart and mind... that way... we will ultimately triumph.

[Muna Wehbe]

{Sam Wahab}

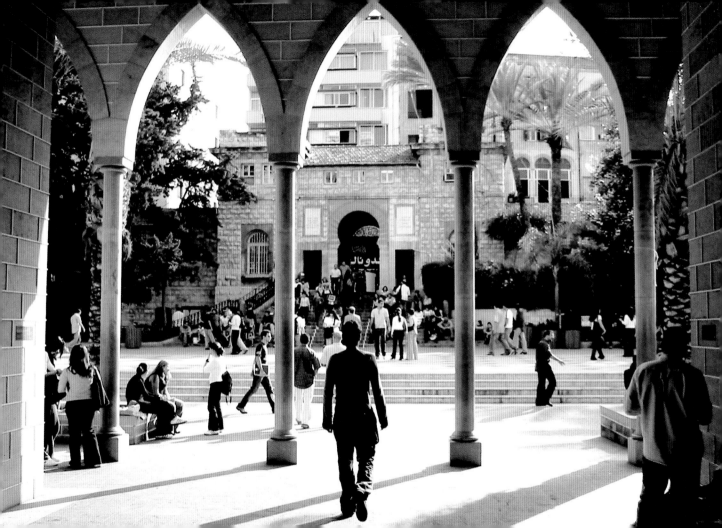

[Said Durra]

SO ALTHOUGH I'M NOT LEBANESE BY BLOOD,

I have become Beiruti. There are plenty of us who fit that description, foreigners who fell in love with the place and its people.

post {Fearlie Wilson} www.slate.com

[Naji Al-Ali]

ou see, this is the thing with us Lebanese l over the world ... we have the strangest, rongest, most passionate relationship th the Lebanon. Even if our great grand-arents are of Lebanese origin and we have ver visited the motherland, the magic there. **sometimes I wonder if all the** banese came back at once, will the untry actually fit them side by side?

post {Ziad Sarkis}

LEBANON

{Nour El Assaad}

translated by Mirvat El-Sibai

[Lana Daher]

OW OUR FACES RESEMBLE THE HEART AND SOUL OF THIS LAND.

w they carry prints of our sand, our dust, our papers and our dates...

How they resemble the vineyards of Bekaa,
the apples of the mountain,
ida's castle and Sour's marina.

How full these faces are of the summer sun,
of December's wrath, of raindrops on the windows and of September's last days.

How our faces scream of springs, of mountain roads, of tree
branches that witnessed our childhood, of stolen first kisses...

How our faces draw smiles out of disasters and print
the tears we dried with laughter...

How you, MY LEBANON, live in our faces...

THANK YOU شكراً MERCI

Souraya Ali, Manar El-Chammas, Dyana Najdi, Tarek Sadi, Tala Tayara and Muna Wehbe
the editorial team - *for their dedication, hard work and above all their humour while creating this book.*

Everyone who helped in gathering content, and all those whose photos and quotes have been used.

And finally **Wehbe Insurance Services** *for their support.*

The texts appear as in the original sources, except where shortened for editorial purposes and where we have made minor alterations to spelling and grammar. We have made every effort to obtain the authors' and photographers' permission for the content of this book.